The Face of Scotland

James Holloway

The Face of Scotland

The Scottish National Portrait Gallery at Kirkcudbright

National Galleries of Scotland · 2008

Convenor's Foreword

Dumfries and Galloway Council is pleased to support Kirkcudbright 2000 host another first class art exhibition in Kirkcudbright. This year's collaborative exhibition with the National Galleries of Scotland is particularly pleasing not only for the quality of its exhibits, but also for confirming the longer-term support of the National Galleries of Scotland for the establishment of an art gallery of national significance in Kirkcudbright.

 The series of exceptional exhibitions arranged by the Kirkcudbright 2000 Committee since 2000 have clearly established a demand for shows of this quality in the town. The economic benefits from their thousands of visitors have helped successfully to promote 'Kirkcudbright – Artists' Town', in combination with the rich variety of leisure and cultural attractions that the area has to offer.

 The Kirkcudbright 2000 Committee, its attendant staff and volunteers, and the Trustees and staff of the National Galleries of Scotland all deserve our thanks in bringing these national art treasures to Kirkcudbright for us to enjoy this summer.

Councillor Patsy Gilroy
Convenor
Dumfries and Galloway Council

Foreword

The Scottish National Portrait Gallery was founded in 1882 after the success of a national campaign to create a specifically Scottish pantheon. While the British Government in London was hostile to the idea, Scottish opinion was supportive. Through the generosity of an initially anonymous donor, Scotland not only founded its national portrait gallery but beat London in creating a purpose-built home for its collection.

Today, we have ambitious plans to renovate the building and to re-present the now extensive collection with the *Portrait of the Nation* project. This major project will ensure that architect Sir Robert Rowand Anderson's Arts and Crafts masterpiece, sited in Queen Street in the heart of Edinburgh, will be lovingly restored and, additionally, will introduce new facilities which will give the Gallery much needed visitor and educational services. To facilitate this, the building will close to the public in the spring of 2009 and will reopen at the end of 2011. The total cost of the project is £17.6 million, of which the Scottish Government has pledged £5.1 million and the Heritage Lottery Fund has allocated a further £4.8 million. The National Galleries of Scotland have launched a campaign to raise the remaining £7.7 million over the next four years.

During the one hundred and twenty years of its existence the collection of the Scottish National Portrait Gallery has grown to reflect Scottish achievement in every field, from the sixteenth century to the present day. Scotland has produced an astonishingly high number of men and women whose lives have inspired and changed the world. This book represents only a few of them, but with Robert Burns and Walter Scott, Eric Liddell and Alex Ferguson, Bonnie Prince Charlie and Queen Victoria, it offers the flavour of the collection.

The National Galleries of Scotland, of which the Scottish National Portrait Gallery is part, is committed to its national role and has been very supportive of Dumfries and Galloway Council's plan to create a permanent art gallery in Kirkcudbright. The National Galleries of Scotland has suggested that when the gallery is built, major works of art from the national collection could be shown in Kirkcudbright on a more regular basis. This exhibition and publication can be seen as an endorsement of our support for the new gallery and a promise of more to come.

John Leighton
Director-General, National Galleries of Scotland

James Holloway
Director, Scottish National Portrait Gallery

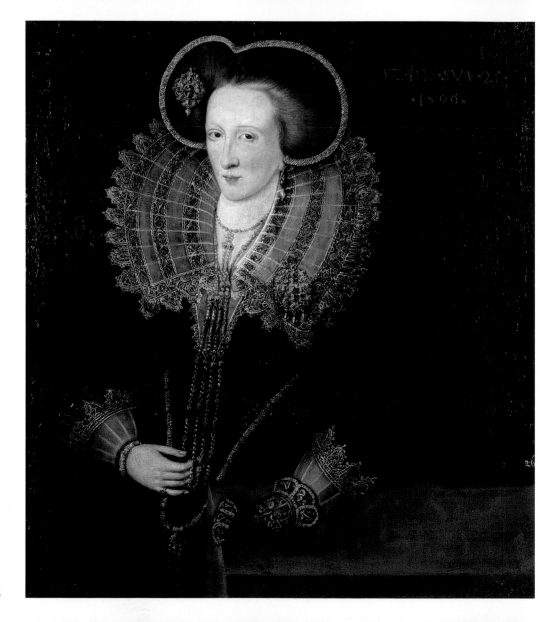

Lady Agnes (Anne) Douglas, Countess of Argyll

c.1574–1607
by Adrian Vanson, 1599

Lady Agnes and her sisters, daughters of the 6th Earl of Morton, were known as 'the seven pearls of Lochleven' on account of their beauty. The sitter was twenty-five when this portrait was painted and had been married for seven years to the 7th Earl of Argyll.

Lady Agnes's plain dress sets off the fine lace collar and cuffs and large quantities of gold, pearl and diamond jewellery. There is a particularly fine pendant pinned to her collar and another in her red hair, which is swept up and padded into a heart-shaped halo.

Oil on canvas, 86.4 × 77.5cm | PG 1409
Bequeathed by the Marquis of Lothian in 1941

King James VI and I

1566–1625

By John de Critz, 1604

This portrait shows James VI of Scotland after he had acceded to the English throne on Queen Elizabeth's death in 1603 and had moved to London. The jewel on his hat, known as the 'Mirror of Great Britain', was made to commemorate the union of the Scottish and English crowns. One of the diamonds had been a gift to Mary, Queen of Scots from her father-in-law, the king of France. Suspended from the 'Mirror' was the most expensive diamond in Western Europe, 'The Sancy', which James had bought specially.

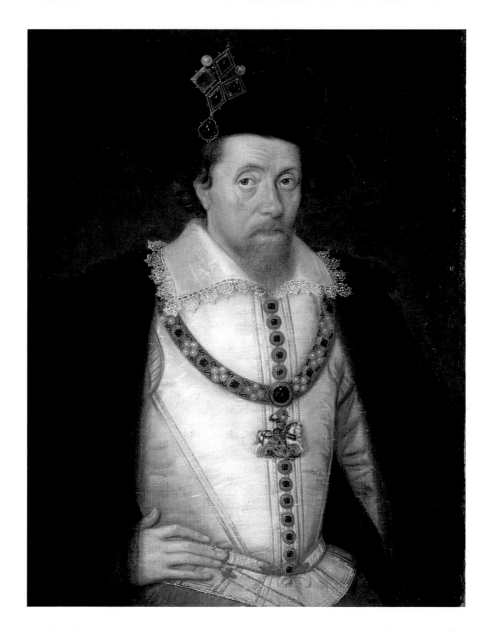

Oil on canvas, 82.9 × 61.9cm | PG 561
Bequeathed by Sir James Naesmyth in 1897

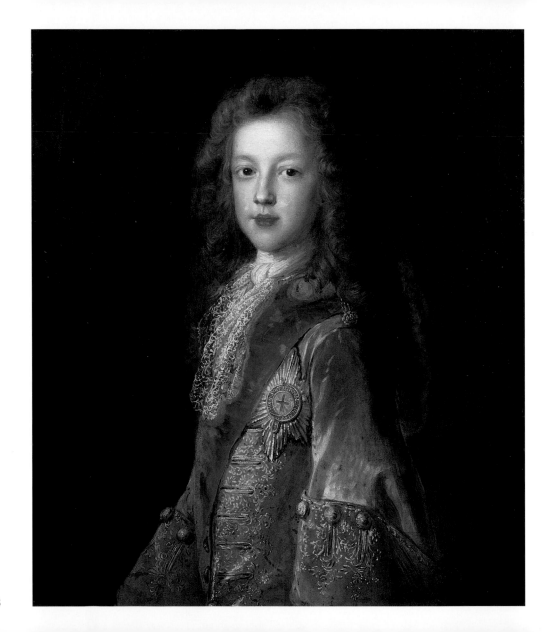

Prince James Francis Edward Stuart
1688–1766
By François de Troy, 1701

The birth of a son and heir to the Roman Catholic King James VII and II in 1688 caused political turmoil in England and Scotland. It led to the successful invasion of England by the Protestant Prince William of Orange and the flight into exile of the royal family and much of the court.

Living in exile in the Palace of Saint-Germain-en-Laye near Paris, the Stuarts used portraiture to reward and remind their supporters. Images of the young prince, the focus of Jacobite hopes for a restoration of the dynasty, were particularly important.

This portrait was probably commissioned by James's mother, Mary of Modena, at the time of the prince's thirteenth birthday.

Oil on canvas, 76.8 × 64.2cm | PG 909
Gifted by C.E. Price in 1920

John Campbell, 3rd Earl of Breadalbane

1696–1782
By Charles Jervas, 1708

This important early depiction of Highland dress was painted in London by the Irish artist Charles Jervas. The elaborate costume and landscape background indicate the status of the young sitter, who, although born in London and educated at Oxford, was heir to one of the great Highland families, the Campbells of Glenorchy. He succeeded his father as earl in 1752.

 As an adult, John Campbell was a diplomat, posted in Denmark and Russia, and a politician, sitting as an MP for Saltash in Devon and Orford in Suffolk. In later life, John Campbell spent much money and energy landscaping the policies surrounding the family seat, Balloch Castle (later rebuilt as Taymouth Castle), on the edge of Loch Tay in Perthshire.

Oil on canvas, 152.4 × 96cm | PG 2934
Bought in 1993 with the help of the National Heritage Memorial Fund and The Art Fund

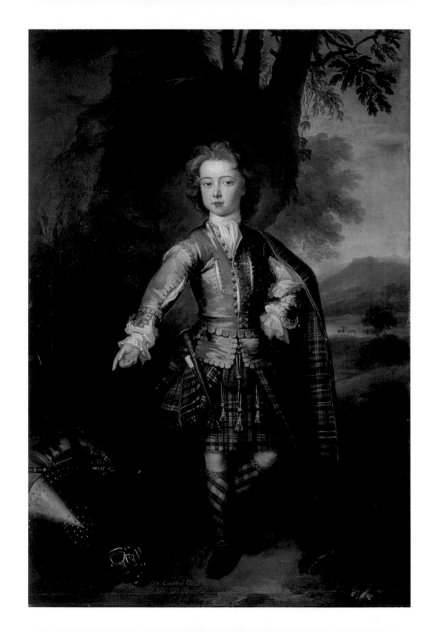

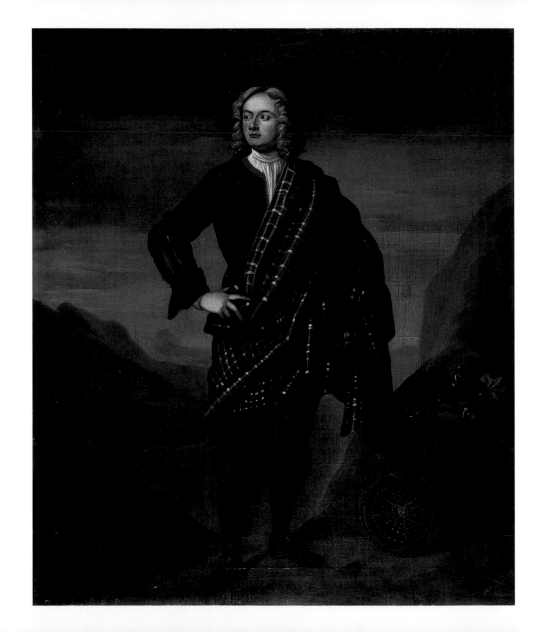

Andrew Macpherson of Cluny
1640–1666
By Richard Waitt, c.1725

Originally called 'Bonnie Prince Charlie',
this portrait is now believed to represent
Andrew Macpherson, the 15th Chief of Clan
Macpherson, who died in 1666 at the age of
twenty-five, on the eve of his wedding.

He was described by a contemporary as 'an
Absalom for beauty, a Joseph for continence,
a Tully for eloquence and a Jonathan for
friendship'. This portrait is an important
example of the depiction of Highland dress.
Macpherson of Cluny is dressed in trews,
jacket and a plaid, in what might be considered
to be the typical style of a Highland gentleman
in riding habit. Since Richard Waitt was
working in the early eighteenth century, this
painting may be a copy of a lost portrait.

Oil on canvas, 76.2 × 64.1cm | PG 1546
Presented by J.A. Pearson in 1950

Field-Marshal George Wade

1673–1748

Attributed to Johan van Diest, c.1731

Born in Ireland of English settlers, Wade was a professional soldier. In 1724 he was appointed Commander-in-Chief of North Britain and sent to the Highlands. He concluded that the main obstacle to 'civilising' the area (and disarming Jacobite opponents of the Hanoverian regime) was the lack of good communications. During the next eleven years Wade supervised the building of over two hundred and fifty miles of roads and around thirty bridges.

This painting shows Wade standing before his most spectacular feat of construction – the road across the Corrieyairick Pass (completed 1731) between Fort Augustus and Dalwhinnie. Ironically, during the 1745 Jacobite Rising, the Jacobites found Wade's roads very useful.

Oil on canvas, 75 × 63.2cm | PG 2416
Bought in 1977

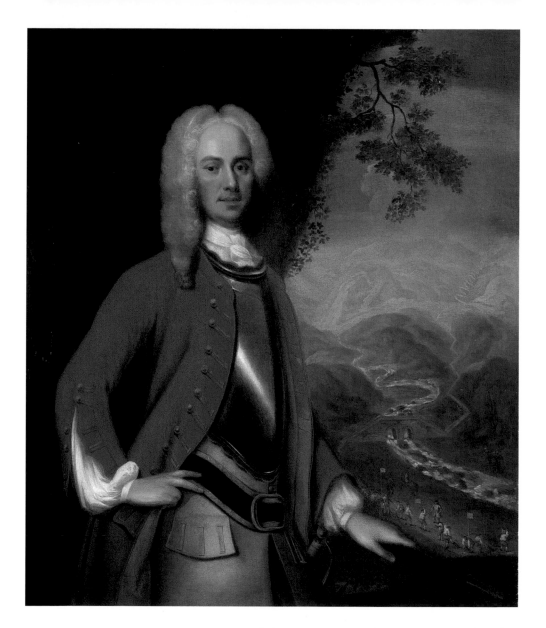

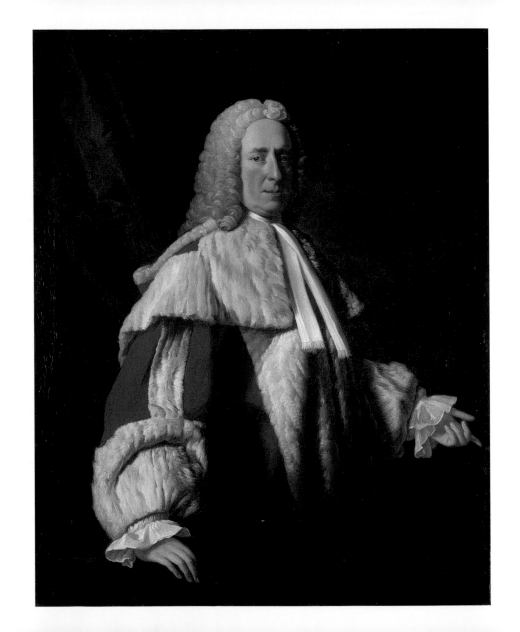

Archibald, 3rd Duke of Argyll

1682–1761
By Allan Ramsay, 1744

Ramsay painted three different portraits of the 3rd Duke of Argyll, each of which was engraved and much copied. The duke was the most powerful political figure in Scotland during the 1740s and 1750s but he was also a personal friend of the artist and the artist's father. This portrait dates from 1744 and shows the duke in legal robes. It was painted the year after he succeeded his brother to the title.

Allan Ramsay's career as one of the leading portrait painters of mid-eighteenth-century Britain was greatly assisted by the 2nd and 3rd Dukes of Argyll. Later their nephew, John, 3rd Earl of Bute, introduced Ramsay to King George III and he became the king's painter.

Oil on canvas, 127 × 101.6cm | PG 1293
Bought in 1936

James Byres (1733–1817) and his Family in Rome

By Franciszek Smuglevicz, c.1776

To the ever changing tourist population of eighteenth-century Rome, James Byres was one of the modern landmarks of the city. The son of committed Jacobites and a Roman Catholic, Byres left his native Aberdeenshire after the failed 1745 Jacobite Rising. In 1758 he moved to Rome where he trained as a painter under Anton Raphael Mengs and studied architecture. His practical knowledge of these two arts was useful to him when he established himself as one of the leading art dealers and professional guides in the city.

One of Byres's best known clients was Edward Gibbon who was introduced to the antique ruins of Rome in an arduous course of visits and lectures lasting many weeks. Byres's greatest coup as a dealer was perhaps his purchase of the Portland Vase, now one of the treasures of the British Museum.

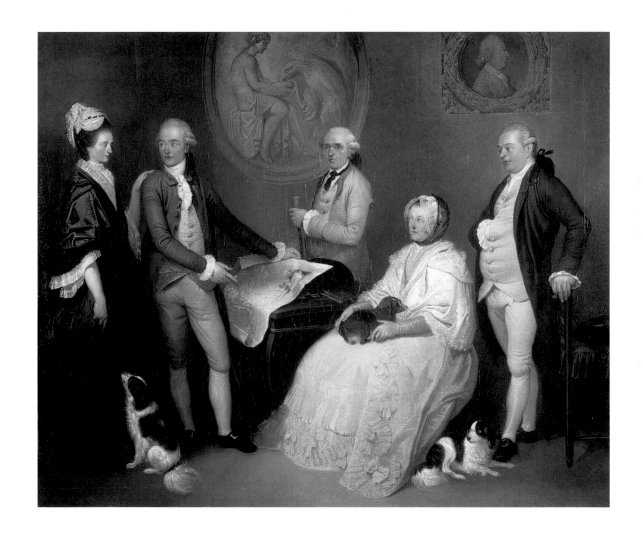

Oil on canvas, 63.2 × 75.8cm | PG 2601
Bought with the help of The Art Fund in 1983

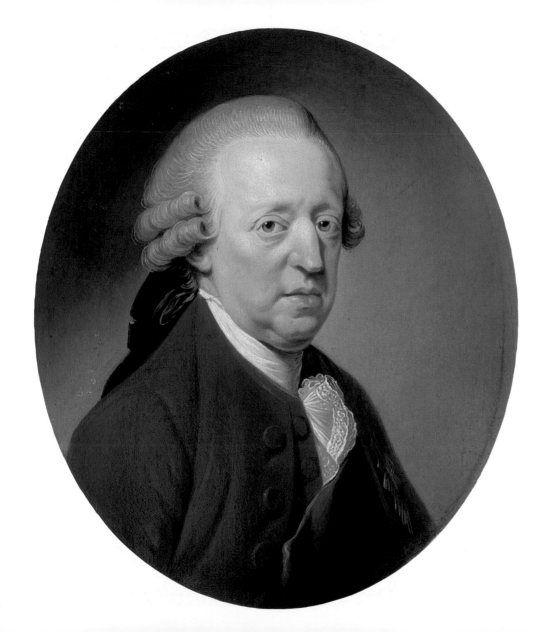

Prince Charles Edward Stuart
1720–1788
By Hugh Douglas Hamilton, 1785

History remembers Prince Charles as Bonnie Prince Charlie, the glamorous though unsuccessful champion of his family's claim to the thrones of England and Scotland. His world fell apart after his crushing defeat at the Battle of Culloden in 1746 and the installation, in the following year, of his younger brother, Henry, as a cardinal in the Roman Catholic Church.

This small portrait was painted in about 1785 when the prince was old and disillusioned. The man who had been the toast of the Jacobites had become something of an embarrassment: a lonely, drunken old man, abandoned by his wife, his mistress and his country.

Oil on canvas, 25.7 × 22cm | PG 622
Bought in 1903

Charlotte Stuart, Duchess of Albany

1753–1789
By Hugh Douglas Hamilton, c.1785–8

Charlotte Stuart was the daughter of Prince
Charles Edward Stuart and Clementina
Walkinshaw. When the couple split up in
1760, Clementina took her daughter with her
and they lived in poverty in France. In 1772
mother and daughter arrived in Rome to seek
legitimacy and financial help from Charles,
but he refused to meet or assist them. Twelve
years later the prince called for his daughter,
legitimised her and gave her the title of the
Duchess of Albany. She became his companion
and carer, dying shortly after him in 1789.

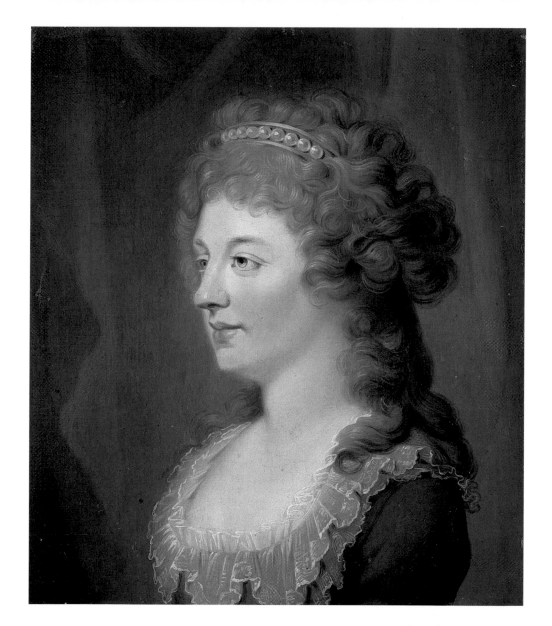

Oil on canvas, 25.7 × 22cm | PG 623
Bought in 1903

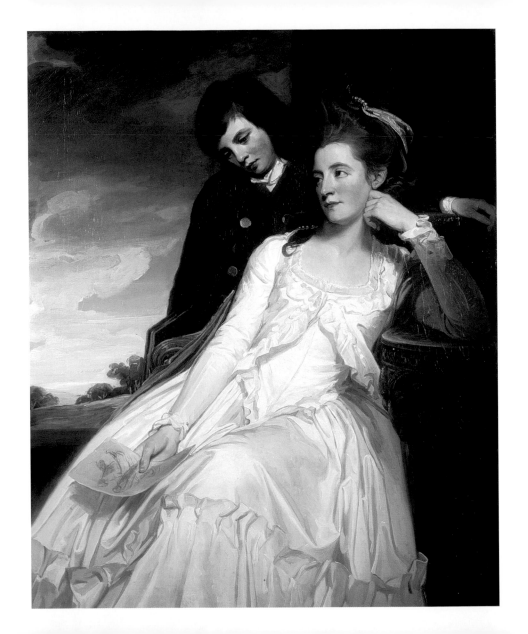

Jane Maxwell, Duchess of Gordon
1748/9–1812
by George Romney, 1778

Jane Maxwell, the daughter of a Wigtownshire baronet, married the 4th Duke of Gordon in 1767. It was not a happy marriage but she had seven children, helped run the vast family estates, and became a leader of fashionable society in London and in Edinburgh. She was a great friend of William Pitt the Younger and her Pall Mall home was the social hub of the Tory party.

Romney's portrait shows Jane Maxwell with her elder son, George Gordon, Marquess of Huntly (1770–1836). Before he succeeded to his father's dukedom in 1778 he had a successful career in the army. His mother is said to have helped him secure new recruits with the incentive of the king's shilling offered from between her lips.

Oil on canvas, 126.4 × 102.5cm | PG 2208
Bought with the help of the Pilgrim Trust in 1972

William Inglis

C.1712–1792
By David Allan, 1787

William Inglis was an Edinburgh surgeon and President of the Royal College of Surgeons. In his spare time, he was a golfer and the captain of the Honourable Company of Edinburgh Golfers.

The artist, David Allan, himself a member of the same golf club, has painted Inglis wearing the jacket and badge of the Honourable Company. The setting is Leith Links, about two miles from Edinburgh city centre and a favourite place for golf since at least the sixteenth century. Behind Inglis, a golf club with silver balls attached – an annual trophy presented by the City of Edinburgh – is paraded by a town officer accompanied by two drummers. On the horizon, just visible, are the pottery kilns of Portobello and North Berwick Law.

Oil on canvas, 129.5 × 105.1cm | PG 1971
Bought in 1961

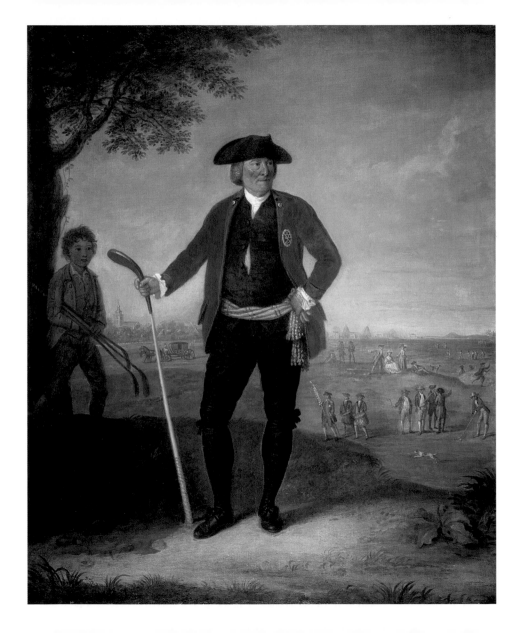

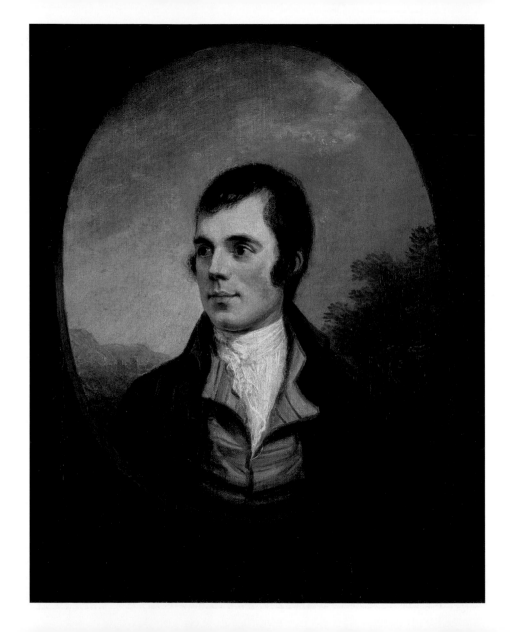

Robert Burns

1759–1796
By Alexander Nasmyth, 1787

The son of an Ayrshire tenant farmer, Burns received a good education and heard traditional songs and ballads from his mother. His first verses were songs to local girls and by the mid-1780s he had emerged as a distinctive poetic voice. However, his efforts at farming met with little success and, reluctant to marry his pregnant lover, Jean Armour, Burns considered emigration to Jamaica. His first published work, the Kilmarnock edition of his poems (1786), was intended to raise the funds for this venture but was so successful that Burns remained in Scotland.

Nasmyth painted this portrait during Burns's visit to Edinburgh in the winter of 1786–7. Burns and Nasmyth became good friends. This is the most famous image of the poet, and was commissioned by the publisher William Creech.

Oil on canvas, 38.4 × 32.4cm | PG 1063
Bequeathed by Colonel William Burns in 1872

William Yellowlees

1796–1855
Self-portrait, 1814

William Yellowlees, who specialised in
small scale portraits, was known by his
contemporaries as 'The little Raeburn'
– an acknowledgement of the quality of his
paintings as much as a comment on their size.
 After working in Edinburgh for about fifteen
years he settled in London where he was
appointed Cabinet Portrait Painter to the Duke
of Sussex. He also enjoyed the patronage
of the prince consort. Yellowlees's success,
however, did not last and he was buried in a
pauper's grave in Brompton Cemetery.

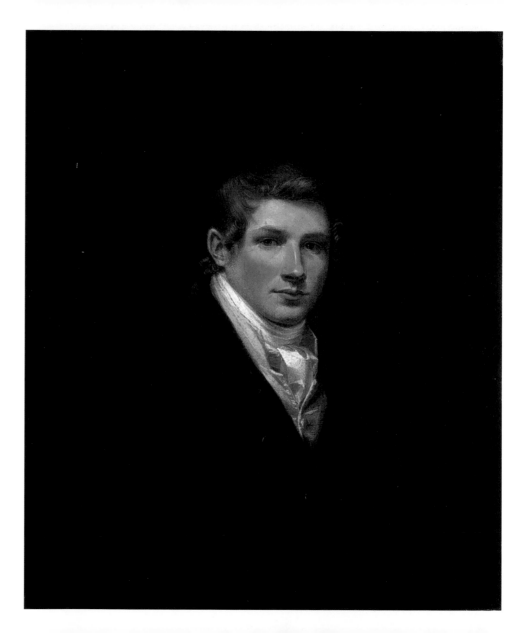

Oil on panel, 24.1 × 19.7cm | PG 1247
Bequeathed by G. Yellowlees in 1934

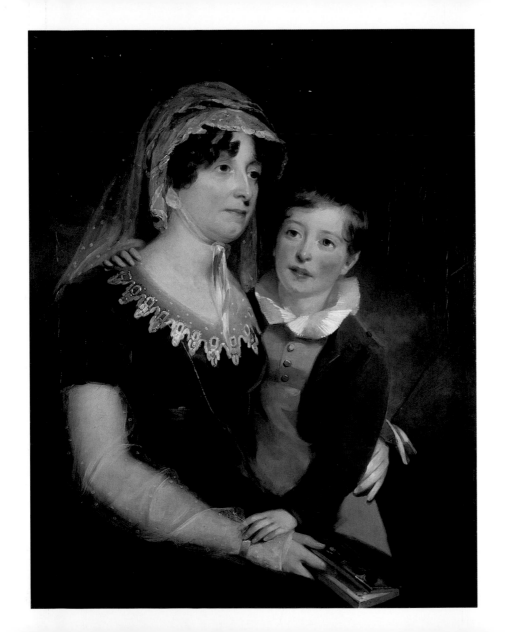

Carolina Oliphant, Baroness Nairne
1766–1845
By Sir John Watson Gordon, c.1818

Born into a staunchly Jacobite family (the
Oliphants of Gask), Lady Nairne was one of
the country's leading songwriters. Her Jacobite
sympathies prompted such works as 'Charlie is
my darling' and 'Will ye no come back again'.
She was an early admirer and supporter of
Robert Burns and in such songs as 'Caller
Herring' and 'The Laird of Cockpen', hardly
his inferior. She is portrayed with her son,
William Murray Nairne. William, whose health
had always been delicate, seems to clasp his
mother for support. He succeeded his father
as Lord Nairne in 1829, but died prematurely in
1837 at the age of twenty-nine.

Oil on canvas, 90.9 × 70.2cm | PG 610
Bequeathed by K. Oliphant in 1903

Sir Walter Scott

1771–1832
By Andrew Geddes, 1822

It is difficult to exaggerate the fame and influence Scott had both at home and worldwide. To the French novelist Balzac he was quite simply 'one of the noblest geniuses of modern times'. His writing, first in verse and later in prose, although much less read now, created a romantic image of Scotland and the Scots which still persists.

 Geddes's portrait was conceived as a preliminary study for a large canvas entitled *The Discovery of the Regalia of Scotland*, which was exhibited at the Royal Academy in 1821. The finished picture, now destroyed, commemorated the rediscovery of the Honours of Scotland on 4 February 1818. Scott instigated and attended the formal opening of the chest in which the crown, sceptre and other relics had been concealed in the Crown Room of Edinburgh Castle.

Oil on canvas, 55.7 × 41.9cm | PG 572
Gifted by J. Rankin in 1898

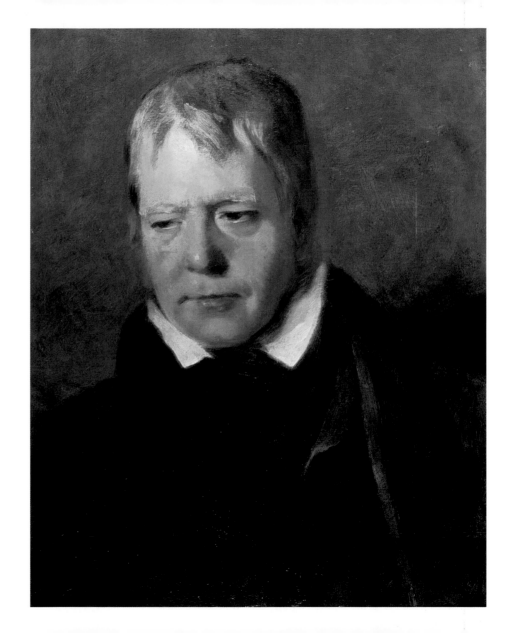

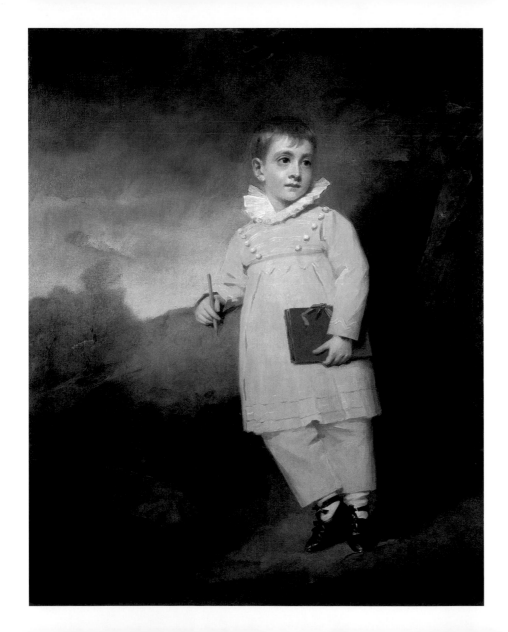

Walter Ross
dates unknown
By Sir Henry Raeburn, *c.*1822

Very little is known about Walter Ross. He was the son of John Ross WS and it is believed that Raeburn painted his portrait in about 1822. Walter Ross is understood to have died soon after.

The painting was displayed in an exhibition Raeburn himself arranged in 1824, a comment, perhaps, on the high quality and appeal of the portrait. It has become known as 'The Yellow Boy', drawing the comparison with Thomas Gainsborough's 'Blue Boy' and Thomas Lawrence's 'Red Boy'.

For fifty years it disappeared from public view and its location was unknown. Quite unexpectedly it was bequeathed to the Scottish National Portrait Gallery in 2002 and this exhibition is the first time it has been displayed in public since then.

Oil on canvas, 127 × 100.3cm | PG 3312
Bequeathed by John Cook in 2002

Angus Mackay,
Piper to Queen Victoria

1812–1859
By Alexander Johnston, 1840

On the recommendation of Lord Breadalbane, Mackay, a distinguished composer as well as performer, was engaged as Queen Victoria's personal piper from 1843 to 1854. This appointment encouraged the Highland Society of London in their aim to preserve the ancient music of the Highlands – Mackay's work still forms the basis of music heard at the Northern Meeting piping competitions.

 By 1853 Mackay had become mentally unbalanced and was committed to the Crichton Royal Asylum, Dumfries, and, after escaping in 1859, he drowned accidentally in the River Nith.

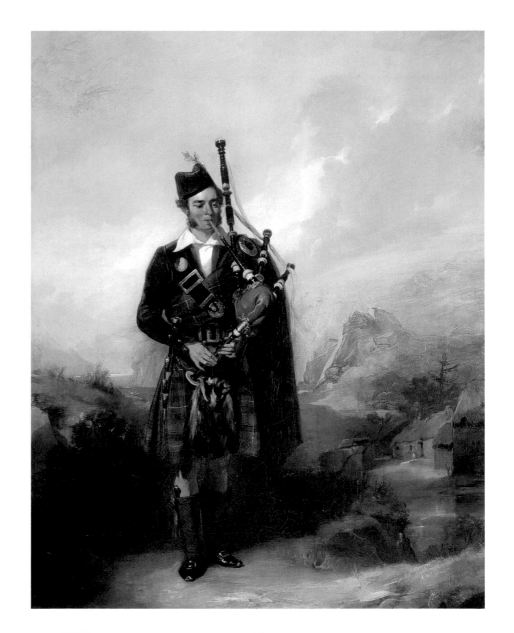

Oil on canvas, 90.2 × 70.5cm | PG 2675
Bought in 1985

David Laing

1793–1878
By Sir William Fettes Douglas, 1862

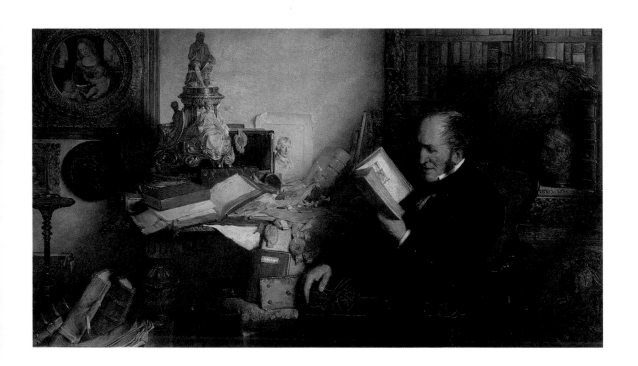

No artist more suitable could have been chosen to paint an antiquary engrossed in his research and surrounded by his papers and collection than Sir William Fettes Douglas. He made a career of painting scenes of this sort, generally choosing subjects from history or fiction, but in David Laing, Librarian of the Signet Library for over forty years, he was able to paint a contemporary who could rival an antiquary or bibliophile of any age.

This portrait was painted as a gift from the artist to the Royal Scottish Academy where Laing was Honorary Professor of Antiquities. His great and numerous holding of old master drawings formed the foundation of the National Gallery of Scotland's collection. Laing's important manuscripts were bequeathed to the University of Edinburgh. This painting records many other aspects of his collection and provides a visual record of his professional career.

Oil on canvas, 25.5 × 63.5cm | PG 2041
Transferred from the National Gallery of Scotland in 1964

Thomas Faed

1826–1900
By John Ballantyne, 1865

Thomas Faed was born in Gatehouse of Fleet. He started work as an apprentice draper at Castle Douglas but soon switched to painting, studying at the Trustees' Academy in Edinburgh. His success was rapid and in 1852 he moved to London where he remained for the rest of his life. Scotland and Scottish scenes, however, provided the inspiration for his work.

 John Ballantyne painted a series of pictures of famous Victorian artists in their studios. This shows Thomas Faed at work on one of his most celebrated paintings, *The Mitherless Bairn* (National Gallery of Victoria, Melbourne). Faed, in common with the other artists whose studios Ballantyne depicted, contributed to the portrait by painting a reproduction of his famous painting on his easel.

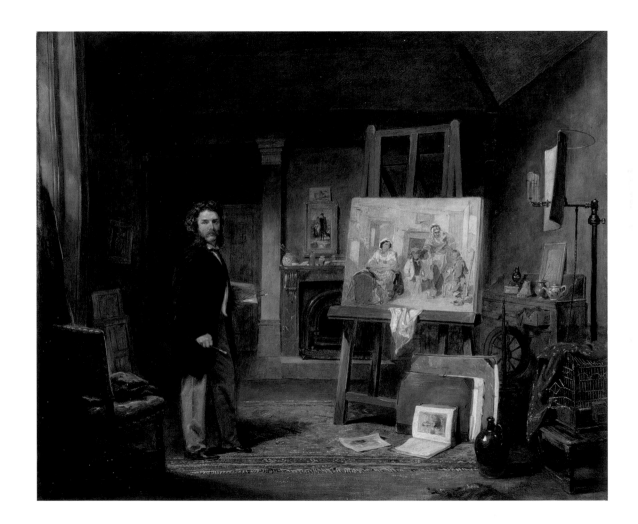

Oil on canvas, 63.5 × 76.2cm | PG 962
Bought in 1923

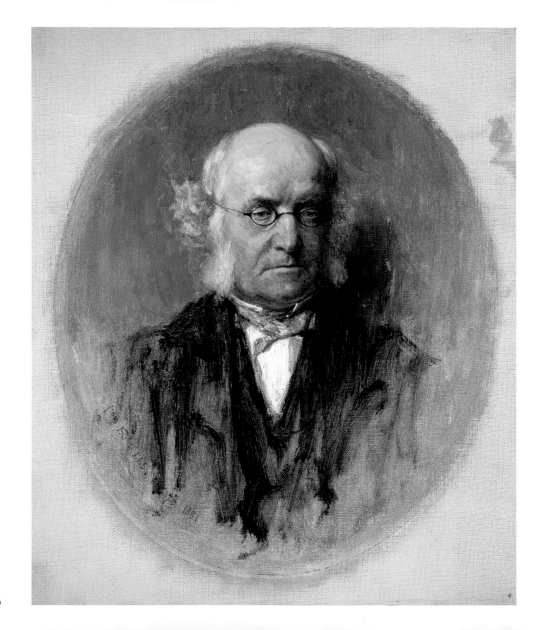

Dr John Brown

1810–1882
By Sir George Reid, 1881

One of the best-loved animal stories in Victorian Scotland was *Rab and his Friends* by John Brown. A native of Biggar, Dr Brown had studied medicine in Edinburgh, then he set up his practice in that city. An author, he declared, should publish nothing 'unless he has something to say and has done his best to say it aright'. Another of his most successful works was *Marjorie Fleming*, a biography of the child poet.

This portrait was painted shortly before Dr Brown's death, by his friend Sir George Reid, the pre-eminent portrait painter of High Victorian Scotland.

Oil on canvas, 34.9 × 29.9cm | PG 290
Gifted by J. Irvine Smith in 1890

The Baptism of
Prince Maurice of Battenburg

By George Ogilvy Reid, 1891

This sketch, for a picture commissioned by Queen Victoria, shows the christening at Balmoral of the queen's grandson, Prince Maurice, on 31 October 1891. The queen holds the baby while Dr Rees, the local minister, pronounces his blessing. It was the first baptism of a royal prince in Scotland for three hundred years, a historic occasion which the queen fully appreciated.

Balmoral, Queen Victoria's favourite residence, lies on the River Dee fifty miles up stream from Aberdeen. She and her consort Prince Albert discovered the old castle in 1848. They bought it four years later and in 1853 laid the foundation stone for a new larger castle on its site, which remains a royal holiday residence to this day.

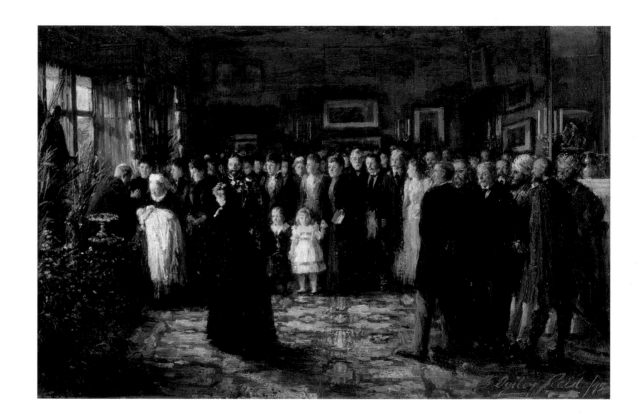

Oil on canvas, 23.8 × 35.7cm | PG 1306
Bought in 1936

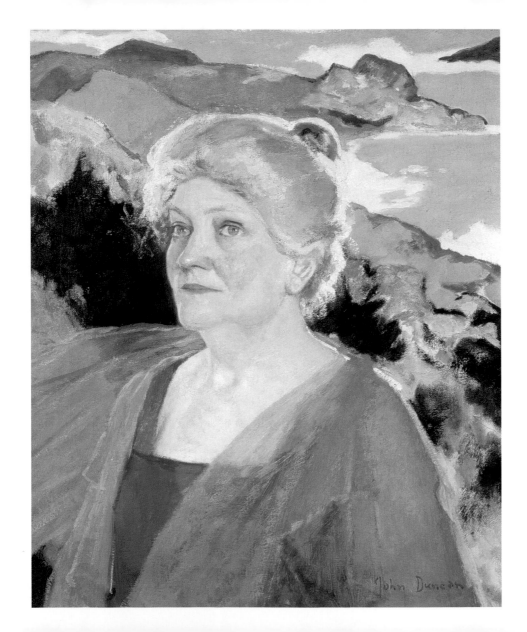

Marjory Kennedy Fraser

1857–1930
By John Duncan, c.1922

Painted in about 1922, this portrait is a
visionary celebration of the Hebridean
landscape which was such a powerful
inspiration to both painter and subject. Their
friendship began in the 1890s when Marjory
Kennedy Fraser was lecturing on Celtic song
in Edinburgh and when John Duncan was
a key figure in the movement for a Celtic
Renascence or Revival.

In 1905 Duncan persuaded Mrs Kennedy
Fraser to visit Eriskay where she began to
collect and arrange the Hebridean folk songs
with which she is still so closely associated.

Oil on canvas, 61 × 50.8cm | PG 2304
Gifted by Mrs A.W. Dawson in 1975

George Walton

1867–1933

By Sir William Oliphant Hutchison, 1923

The twelfth child of a particularly talented Glasgow-based family, George Walton was rescued from his post as clerk in the British Linen Bank by Catherine Cranston, who commissioned him to decorate her Argyle Street tea rooms in 1888. The same year Walton set up his own company, described as 'Ecclesiastical and House Decorators', and enjoyed rapid success, designing further premises for Miss Cranston and interiors for prestigious clients such as the shipping magnate William Burrell. His firm offered a complete interior design service, providing wallpapers, stencil work, stained glass, furniture and metalwork, all fashioned in a unified Arts and Crafts idiom at the forefront of the progressive Glasgow Style.

William Oliphant Hutchison was married to Margery, daughter of George's elder brother, the painter Edward Arthur Walton.

Oil on canvas, 81.8 × 70.6cm | PG 3026
Bought in 1997

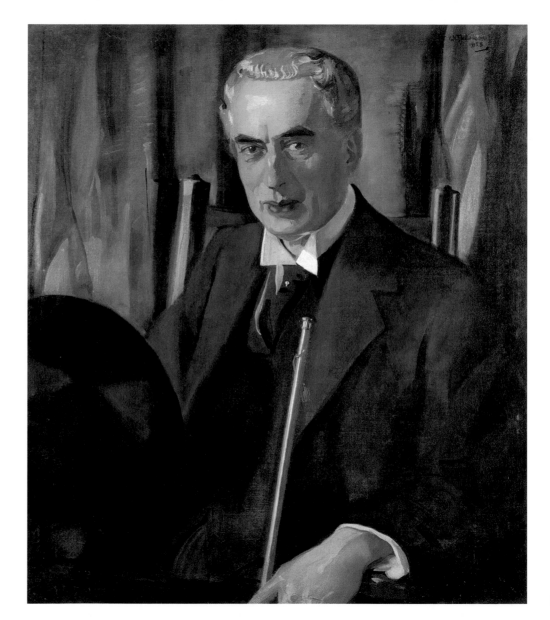

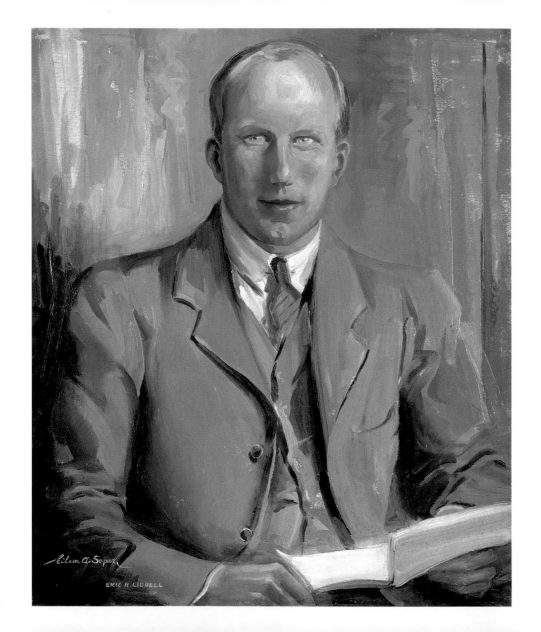

ERIC H LIDDELL

Eric Liddell
1902–1945
By Eileen Soper, 1925

On 10 July 1924 at the Paris Olympic Games, Eric Liddell won a gold medal in the men's 400 metres in a world-record time of 47.6 seconds. His success was all the sweeter in that he had debarred himself from competing in the 100 metres, for which he was favourite, by refusing to run in the heats because they were being held on a Sunday.

A fervent evangelical Christian, Liddell left Scotland in 1925, shortly after this portrait was painted. He took up an appointment as a missionary teacher in Tientsin near Peking. (He had been born in China, the son of Scottish missionaries.) In 1943, at the time of the Japanese invasion of China, Liddell was interned. He died in a Japanese camp two years later of a brain tumour.

Oil on canvas, 73.5 × 61.5cm | PG 2992
Bought in 1995

Duncan Macrae

1905–1967
By William Crosbie, c.1938

Duncan Macrae has been called the greatest actor that Scotland ever produced. A notable figure on the postwar Scottish stage, his angular face and lantern jaw matched a singular, eccentric personality. His wide-ranging acting skills guaranteed his success as a character actor in plays, variety, pantomime and film. From the late 1950s Macrae worked increasingly in television.

Duncan Macrae and the painter William Crosbie were part of the same circle of friends in pre-war Glasgow. During this period Macrae was teaching in Rothesay but frequently visited his friends. Crosbie often provided Macrae with a bed in his Glasgow studio, and later recalled: 'what better opportunity to paint him'.

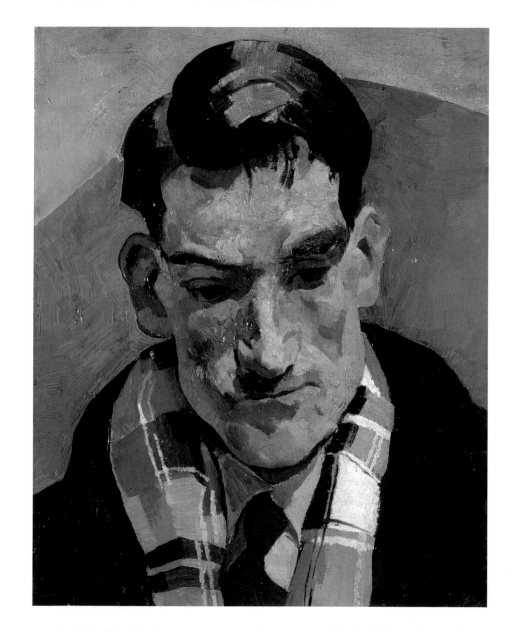

Oil on canvas, 45 × 34.8cm | PG 2947
Bought in 1994

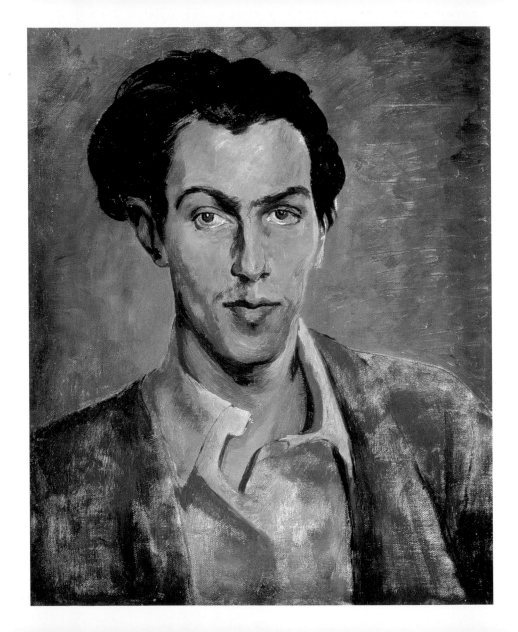

Robert Colquhoun

1914–1962
Self-portrait, c.1940

Born in Kilmarnock, Robert Colquhoun won a scholarship to Glasgow School of Art where he met his lifelong partner Robert MacBryde. 'The Roberts', as they were known, shared a studio in London with John Minton which became a centre for the British avant garde.

Colquhoun is best known for his angst-ridden pastoral paintings but he also designed several theatre sets, including the costumes and scenery for Massine's ballet *Donald of the Burthens*.

Oil on canvas, 41 × 33cm | PG 2815
Bought with the help of The Art Fund in 1990

Dame Flora MacLeod of MacLeod
1878–1976
By Dennis Ramsay, 1960

Dame Flora was born at No. 12 Downing Street, the home of her maternal grandfather, Sir Stafford Northcote, who at the time was Chancellor of the Exchequer.

She inherited the chieftainship of the Clan MacLeod from her father Sir Reginald MacLeod of MacLeod and on his death in 1935 dedicated her life to the clan, Dunvegan Castle its seat, and to the Isle of Skye.

Dame Flora was one of the first clan chiefs to understand the importance of the widely dispersed members of the clan. She travelled tirelessly in North America, Australia and New Zealand founding clan societies and generating publicity for Dunvegan and Skye. Her energy was rewarded in 1953 when American support helped to pay for essential repairs to Dunvegan Castle roof. In the same year she was awarded Dame Commander of the Order of the British Empire.

Oil and tempera on canvas, 61 × 50.8cm | PG 3399
Bought in 2004

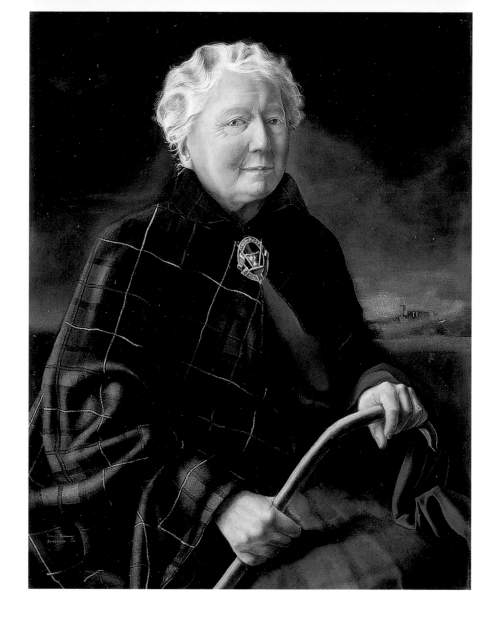

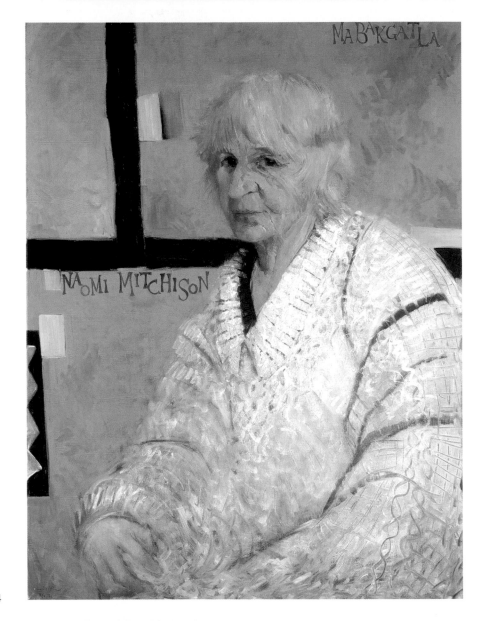

Naomi Mitchison, Lady Mitchison

1897–1999
By Clifton Pugh, 1974

This portrait of the writer and socialist Naomi Mitchison was painted by the Australian artist Clifton Pugh. Mitchison had seen his work exhibited at a London gallery and asked to be introduced to him if he came to Britain. In 1974 Pugh stayed with her in London and painted this portrait. Two years later he visited her at Caradale House in Kintyre which she and her husband, the Labour MP Dick Mitchison, had bought in 1937.

From the 1960s Africa became a great interest for Lady Mitchison. She raised money for educational and economic projects in Botswana and in 1963 she was made Mabakgatla or mother of the Bakgatla tribe.

Oil on canvas, 101.6 × 76.2cm | PG 3163
Bought in 1999

Queen Elizabeth,
The Queen Mother

1900–2002
By Avigdor Arikha, 1983

Elizabeth Angela Marguerite Bowes-Lyon, youngest daughter of the 14th Earl of Strathmore, married the Duke of York (later King George VI) in 1923.

 This portrait was painted at Clarence House in the course of the afternoon of 6 July 1983. It had been preceded by an earlier meeting between artist and sitter when the portrait was discussed and a preliminary drawing done. Unlike most royal portraits, it is not concerned with public status but rather the private person rarely seen. The painting is characterised by supremely delicate handling of paint and a simple colour range of great luminosity.

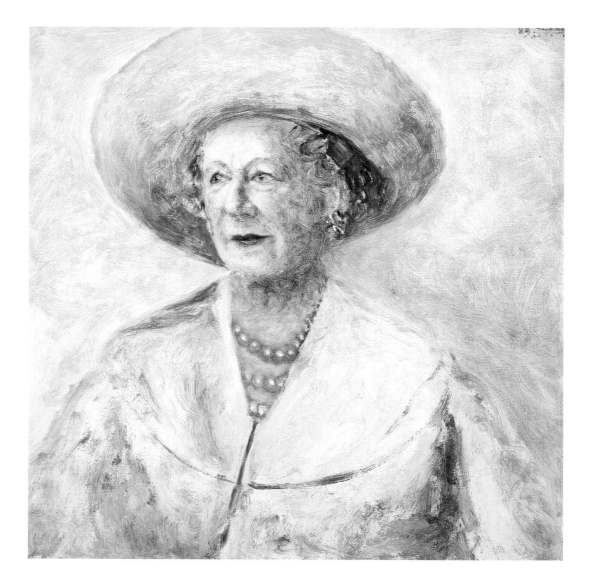

Oil on canvas, 49.7 × 50.3cm | PG 2598
Commissioned by the Scottish National Portrait Gallery in 1983

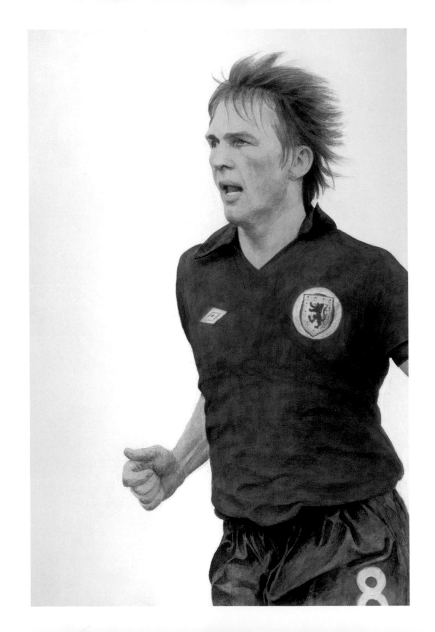

Kenneth Dalglish
born 1951
By Mark I'Anson, 2003

Kenny Dalglish is widely regarded as the most successful British footballer of his generation. A prolific goal scorer, he was the first ever to score a hundred goals in both the English and Scottish leagues. Born in Glasgow, he grew up supporting Rangers, but it was the rival club Celtic who signed him in 1967. Dalglish appeared in the first team in 1970, after which he helped Celtic win four championships, four Scottish Cups and one League Cup. In 1977 Dalglish moved to Liverpool for a record fee of £440,000.

At Anfield he was part of the teams that won the European Cup in 1978, 1981 and 1984. Winning a total of one hundred and two selections for Scotland, in 1985 he was appointed player-manager at Liverpool and his immediate League and Cup 'double' formed the start of a successful managerial career.

Mixed media on paper, 178 × 117cm | PG 3343
Commissioned by the Scottish National Portrait Gallery in 2003

George Young

1922–1997
By Mark I'Anson, 2003

George Lewis Young spent his entire adult
career with Rangers, with whom he won six
Scottish League championships, four Scottish
Cups and two League Cups. At six feet two
inches and weighing more than fifteen stone,
he dominated Rangers's mean defence as
a centre half or right back during the years
immediately after the Second World War.
His nicknames included 'Gentle Giant', 'Rock
of the North' and 'Corky', the last because
he always carried a champagne cork from
the celebrations which followed Scotland's
3–1 victory over England in 1949. In total,
Young won fifty-three caps and captained
Scotland on forty-eight occasions. He was
highly respected by both his own team mates
and his opponents, and was never in his
career sent off during a match. This painting
is part of 'Scotland's Dream Team', a series
commissioned by the Scottish National
Portrait Gallery in 2003.

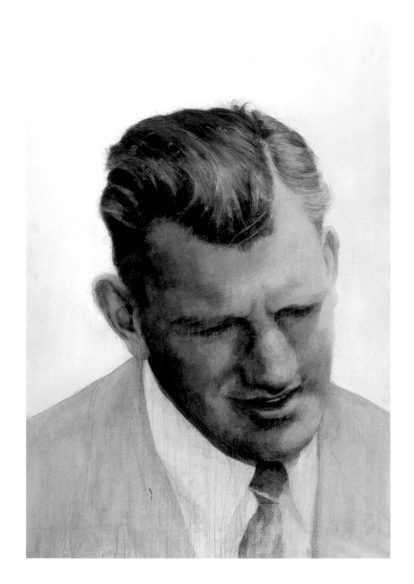

Mixed media on paper, 176 × 110cm | PG 3337
Commissioned by the Scottish National Portrait Gallery in 2003

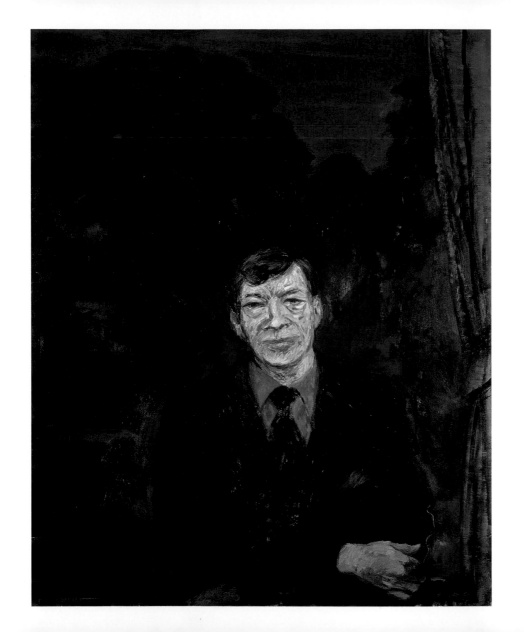

Sir Alexander Gibson

1926–1995
By John Houston, 1985

Alexander Gibson dominated Scotland's classical music scene in the latter half of the twentieth century. In 1959 he became the first Scottish-born principal conductor of the Scottish National Orchestra and he was one of the key figures in creating Scottish Opera three years later. Under the baton of Gibson, Scottish Opera became a truly national company with an international reputation. After twenty-five years with the company Gibson turned freelance, enabling him to conduct across the world.

He was knighted in 1977 and the following year awarded the Sibelius Medal by the Government of Finland. This recognised his achievement and his lifelong admiration and promotion of the music of the great Finnish composer.

Oil on canvas, 127 × 101.6cm | PG 2691
Gifted by the artist in 1986

Baroness Thatcher of Kesteven

born 1925
By David Donaldson, 1986

Margaret Thatcher was not just the first woman to become prime minister of the United Kingdom but the longest serving premier of the twentieth century, winning three general elections in a row. Her achievement was to change the face of Britain. She did this by challenging and defeating union power and by privatising state monopolies. Her success in the Falklands War and her close partnership with American President Ronald Reagan, helped boost her reputation which, towards the end of her premiership, was higher abroad than at home.

 This portrait was commissioned by Lord Macfarlane of Bearsden from Her Majesty's Painter and Limner in Scotland, David Donaldson.

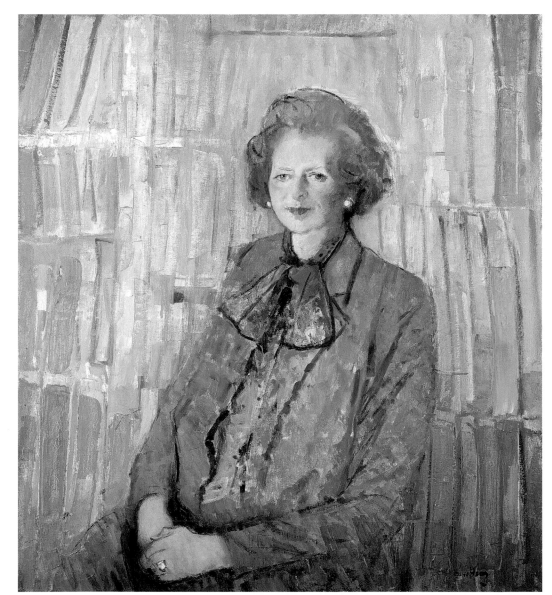

Oil on canvas, 101 × 91.5cm | PG 2706
Presented by Lord Macfarlane of Bearsden in 1986

Mollie Hunter

born 1922
By Elizabeth Blackadder, 1988

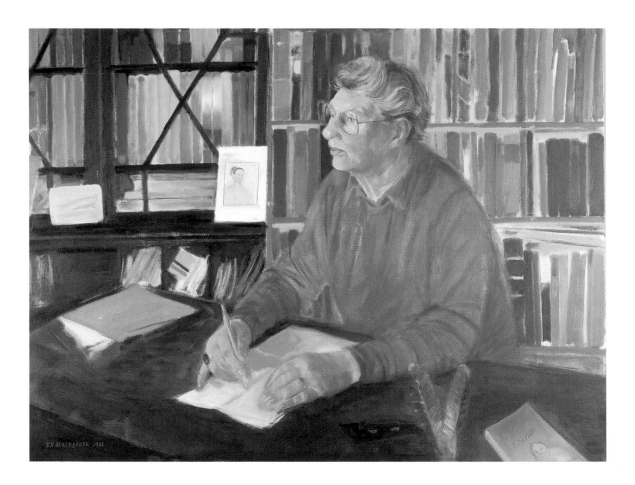

Mollie Hunter is an internationally acclaimed writer of novels for children and young adults, including *A Sound of Chariots* and *The Mermaid Summer.* The former, a story of poverty, adolescence and achievement in an East Lothian setting influenced by Mollie's own upbringing, is a classic by any standards.

 The artist is one of Scotland's finest contemporary painters, perhaps better known for still lifes and plant paintings of supreme sensitivity. In 2001 she became the first woman to be appointed Her Majesty's Painter and Limner in Scotland.

Oil on canvas, 76.5 × 101.6cm | PG 2735
Commissioned by the Scottish National Portrait Gallery in 1988

Robbie Coltrane (Anthony Robert McMillan) as Danny McGlone

born 1950
By John Byrne, 1988

Robbie Coltrane came to prominence with the rise of television's alternative comedy scene in the early 1980s. He starred in thirteen performances for the anarchic 'Comic Strip' series, and received the Peter Sellers Award for Comedy for his contribution to film comedy. Coltrane, who was born in Rutherglen and was a student at Glasgow School of Art, has been associated with John Byrne at several stages of his career. He was in the original production of Byrne's stage play, *The Slab Boys* and its sequel *Cuttin' a Rug*. This portrait by Byrne, shows the actor in the character of Danny McGlone from Byrne's television comedy series *Tutti Frutti*, for which Coltrane won his first nomination as best actor for a BAFTA award.

In 2006, Coltrane was awarded the OBE. His most recent role is as Hagrid, the kindly giant in the Harry Potter films.

Oil on board, 30 × 21.3cm | PG 3116
Purchased in 1998

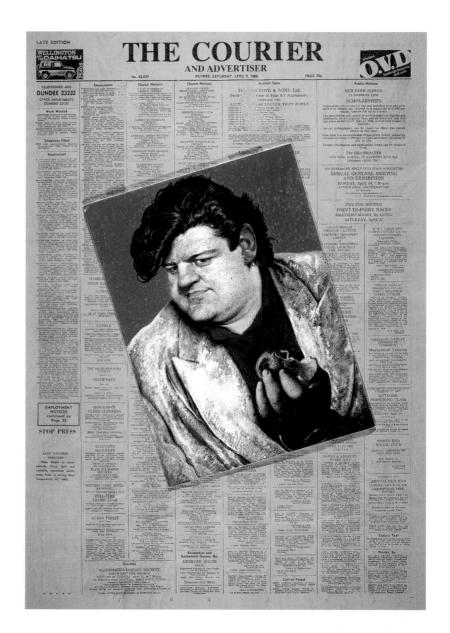

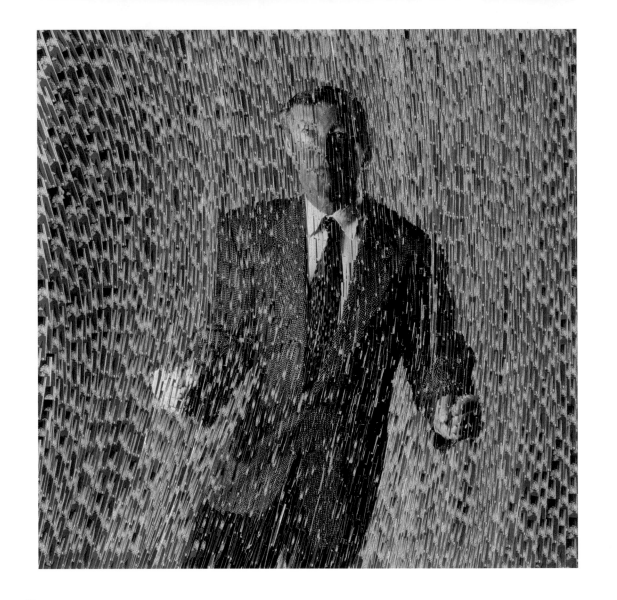

Sir Alex Ferguson

born 1941
By David Mach, 1996

Born in Govan, Alex Ferguson played football for Glasgow schools and Scotland schools before joining Queen's Park Football Club as an amateur in 1957. He subsequently played with several clubs, including Dunfermline Athletic and Rangers, as a professional.

In 1974, Ferguson was appointed manager of East Stirlingshire and began a second highly successful career, in club management. In 1978 he joined Aberdeen and guided 'The Dons' to three Premier League titles, four Scottish Cup victories and one League Cup win, breaking the 'Old Firm' trophy stranglehold. In 1983, Aberdeen defeated the favourites, Real Madrid, to lift the European Cup Winners' Cup.

In 1986, Ferguson moved to Manchester United Football Club. His success there has been phenomenal. In 1999 he won the treble – the League Cup, the FA Cup and the European Cup – surpassing the legendary Sir Matt Busby for the number of trophies his teams have brought back to Old Trafford. This year, under Sir Alex, Manchester United are the European and Premier League champions.

Postcard and photograph collage, 181 × 181cm | PG 3044
Bought with the help of The Art Fund in 1997

Rikki Fulton

1924–2004
By Thomas Kluge, 1997

Rikki Fulton was greatly admired as one of
Scotland's finest actors and comedians. In the
1950s he starred in 'The Five Past Eight' shows
in Glasgow and Edinburgh, and he regularly
topped the bill in variety and pantomime.
With Jack Milroy as his partner in the role of
Francie, Rikki Fulton played Josie, two Glasgow
wide boys in a memorable double act. In
1985 he appeared on screen in *A Wee Touch
of Class*, which he co-adapted from Molière's
play *Le Bourgeois Gentilhomme*, changing its
period and setting from seventeenth-century
France to nineteenth-century Edinburgh. In his
performance as the Reverend I.M. Jolly, Fulton
created one of the legendary comic figures of
modern Scottish television.

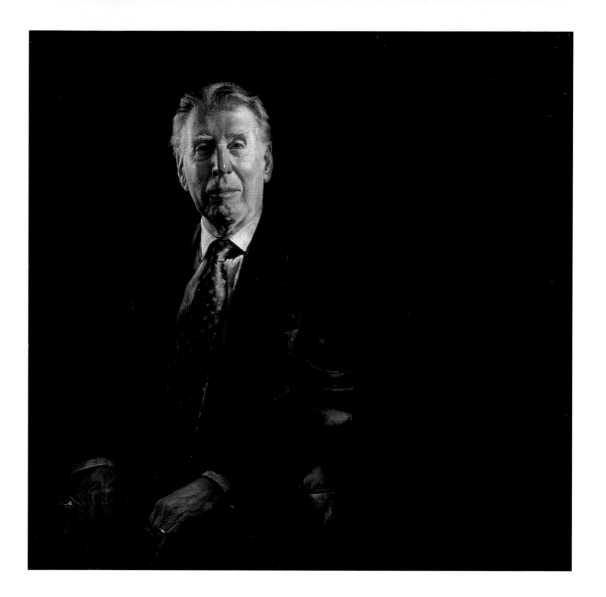

Acrylic on canvas, 80.5 × 80.5cm | PG 3033
Commissioned by the Scottish National Portrait Gallery in 1997

Hamish MacInnes

born 1930
By Robert Maclaurin, 2002

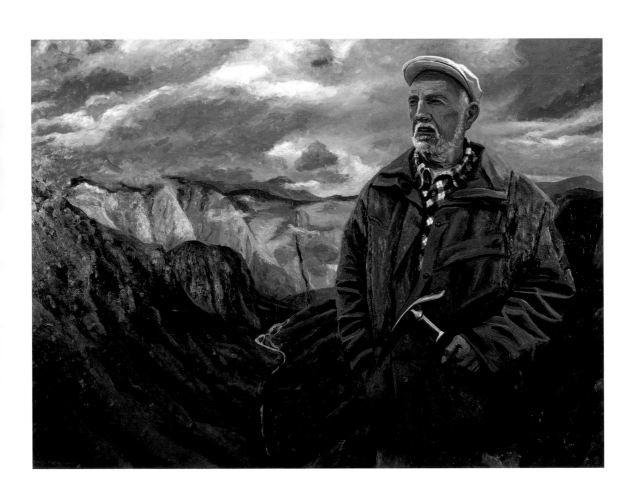

Mountaineer, writer, documentary maker and founder member of the Glencoe Mountain Rescue Team in 1960, Hamish MacInnes first started climbing as a member of the Glasgow-based Creag Dhu club. His first ascent of Zero Gully on Ben Nevis in 1957 was one of the breakthroughs in British mountaineering. Abroad, he has climbed in the Alps, New Zealand, the Caucasus and the Himalayas. He joined John Cunningham in the celebrated Creag Dhu Everest expedition in 1953. He was a member of the two South-West-Face Teams in 1972 and deputy leader of the successful British Everest Expedition in 1975.

Robert Maclaurin met Hamish MacInnes at his home in Glencoe and made sketches of him and the surrounding mountains, which the artist himself had climbed as a young man. Maclaurin completed his portrait in Australia where he now lives and paints.

Oil on canvas, 97 × 130cm | PG 3317
Commissioned by the Scottish National Portrait Gallery in 2002

Donald Dewar

1937–2000
By Archie Forrest, 2002

Donald Dewar became Scotland's first First
Minister on 6 May 1999. His sudden death
less than eighteen months later shocked the
nation. Dewar practised as a solicitor in his
native Glasgow until he won the Aberdeen
South constituency for the Labour party in
1966. He later represented constituencies in
Glasgow at Westminster.

 Archie Forrest's sculptural tribute to his
friend and neighbour has Donald Dewar's head
resting on a pile of books. The politician was a
great bibliophile and at his death his collection
of books and memorabilia was gifted by his
children to the new Scottish Parliament.

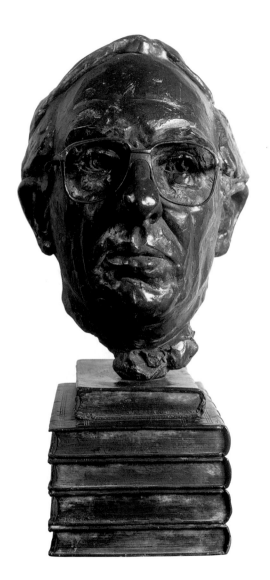

Bronze, height 41.8cm | PG 3279
Commissioned by the Scottish National Portrait Gallery
and presented by the Friends of the National Galleries
of Scotland in 2002

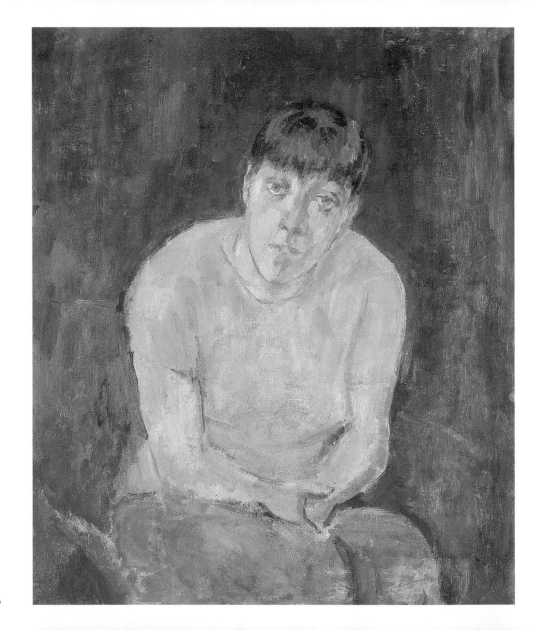

Caroline Innes

born 1974
By John Lessore, 2004

Caroline Innes, who is confined to a wheelchair by cerebral palsy, is an athlete and part-time lecturer based in Fife. She has been British Champion since 1989 and was voted Young Disabled Sportswoman of the Year in 1993, following her 100 metres triumph at Barcelona in 1992. She won two gold medals and a silver medal at the Sydney Olympic Games and has been awarded an MBE. She has now retired from international athletics to concentrate on her family.

 This sketch is a study for a large group portrait of six British paralympic athletes commissioned by the National Portrait Gallery in London in 2004.

Oil on canvas, 61.5 × 51cm | PG 3376
Bought in 2004

Muriel Gray

born 1959
By Iain Clark, 2005

Author, broadcaster and newspaper columnist, Muriel Gray was born in East Kilbride. She was educated at Glasgow School of Art and became Assistant Head of Design at the National Museum of Antiquities based in Edinburgh. She was also a member of the rock group 'The Von Trapp Family' and this led to her becoming a presenter on the Channel 4 television series *The Tube* in 1982. Gray then became familiar as the presenter of a range of television programmes, including *The Media Show* (1987–9). She started her own television production company, 'Gallus Besom' in 1989 and in 1991 produced *The Munro Show* which saw her climbing the mountains of Scotland. Muriel Gray became the first female rector of the University of Edinburgh, a post she held from 1988 to 1991.

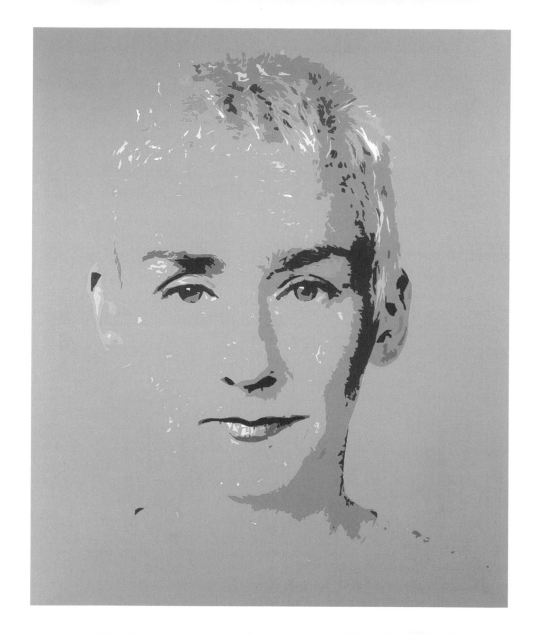

Giclée print on canvas, 86 × 71cm | PG 3408
Bought in 2005

Index of Sitters

Published by the Trustees of the National Galleries of Scotland to accompany the exhibition *The Face of Scotland: The Scottish National Portrait Gallery at Kirkcudbright*, held at Kirkcudbright Town Hall, St Mary Street, Kirkcudbright from 5 July to 25 August 2008.

Text © The Trustees of the National Galleries of Scotland 2008

ISBN 978 1 906270 13 1

Designed and typeset in Bliss Pro by Gravemaker+Scott

Printed on Chromomatt 170gsm by Die Keure, Belgium

Cover: details from the works on pages 6, 7, 9, 14, 18, 28, 32, 33, 43, 46

National Galleries of Scotland is a charity registered in Scotland (No.SC003728).

The proceeds from the sale of this book go towards supporting the National Galleries of Scotland.

www.nationalgalleries.org

All photography © Antonia Reeve Photography

Copyright credits: page 28 © Estate of John Duncan. All rights reserved, DACS 2008; 29 © The Family of the Artist; 30 courtesy Chris Beetles gallery on behalf of the AGBI; 31 © By kind permission of the Crosbie Estate; 32, 41 copyright care of The Bridgeman Art Library/Artist/Artist's estate; 33 © Francis Dennis Ramsay, his family and descendents; 35 © Avigdor Arikha; 36, 37 © Mark I'Anson; 38 © John Houston R.S.A.; 40 © Elizabeth Blackadder; 42 © David Mach; 43 © DACS 2008; 44 © Robert Maclaurin; 45 © The Artist and his Estate; 46 © John Lessore; 47 © Iain Clark